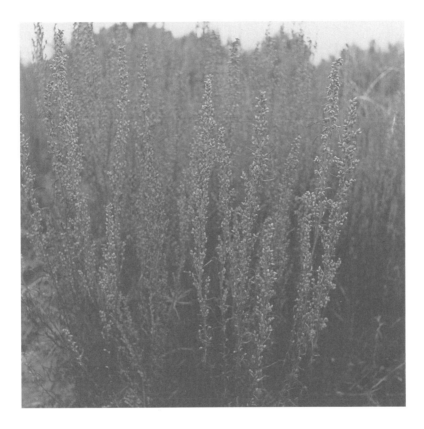

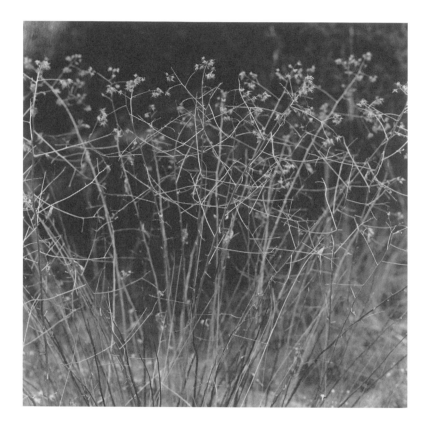

HERE · INGS

a sonic geohistory

text and sound by

STEVE PETERS

photographs by

MARGOT GEIST

LA ALAMEDA PRESS

Albuquerque

ISBN No.
1-888809-38-83

First Edition, 2002

Cover photograph by Margot Geist
Book design by Michael Motley

La Alameda Press
9636 Guadalupe Trail NW
Albuquerque, NM 87114 USA

for Christine Wallers, who knew

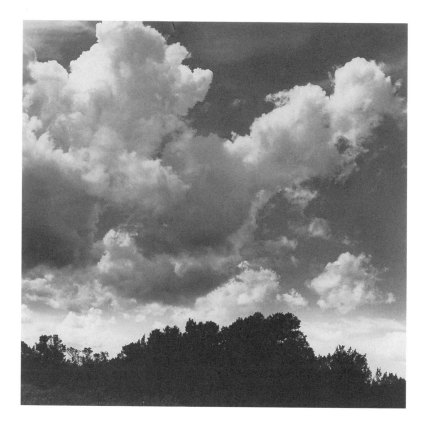

After all, anybody is as their land and air is. Anybody is as the sky is low or high, the air heavy or clear and anybody is as there is wind or no wind there. It is that which makes them and the arts they make and the work they do and the way they eat and the way they drink and the way they learn and everything.

GERTRUDE STEIN, *An American and France*

INTRODUCTION

This project, while being ostensibly concerned with environmental sound, is not about "nature recording" in the usual sense. It does not present the seldom-heard sounds of exotic creatures or unspoiled ecosystems. Nor is it intended as music, or mood enhancer, and certainly not as science. These sounds and words document an experiential process that I undertook at (and with) a particular place during a given period of time. To the extent that they express my personal observations, impressions, sensations, and aesthetic inclinations, this is an honest portrayal. Whether or not it accurately represents that place, or some greater reality beyond my own perception, is another matter.

I am aware that, on one level, the sounds in question are not obviously remarkable or dramatic. In fact, they are quite literally mundane. Which is to say they are sublime. I hear them as evidence of Life in progress, a landscape being and becoming, a web of communication and interaction, time passing, presence.

I know that these crude artifacts can give only the vaguest approximation of the essential nature of that place, of what happened there, of the act of engaging with it in real time. I wonder if I can adequately convey the simple beauty and richness of that raw sensual experience, the emotional resonance of it. Ultimately, any attempt at documentation falls short of actual lived experience. But if this work can encourage others to slow down, be quiet, and listen deeply to the voices of whatever places they may visit or inhabit, I'll be satisfied.

S.P.

THE PROJECT

As time went by, I realized that the particular place I'd chosen was less important than the fact that I'd chosen a place and focused my life around it … What makes a place special is the way it buries itself inside the heart, not whether it's flat or rugged, rich or austere, wet or arid, gentle or harsh, warm or cold, wild or tame. Every place, like every person, is elevated by the love and respect shown toward it, and by the way in which its bounty is received.

RICHARD NELSON, *The Island Within*

PLACE & PROCESS

THE LAND/AN ART SITE—forty acres of piñon, juniper, shrubs, grasses, cactus, and rocks—is located in the high desert of central New Mexico, tucked away in the foothills of the Manzano Mountains just outside the sweetly decrepit town of Mountainair. To the east lie a series of rugged mesas, and beyond them the edge of the Great Plains. It is a place of austere beauty, typical of this part of the southwestern United States: striking colors of earth and rock, vast skies, distant horizons, strong winds, sudden changes in weather. At first glance the vegetation seems quite sparse; upon looking closer one notices a surprising variety of plant life. The same is true for other living creatures, and this is mirrored by the soundscape.

But this area, known locally as Loma Parda, is not a remote wilderness. People do live nearby, and the sounds of distant voices, power tools, car engines, barking dogs, and sizzling high voltage power lines mix with bird calls, insects, and wind, as do the many trains that run parallel to the highway two and a half miles away, and the jets flying frequently overhead. Still, silence is the prevailing feature. There is none of the sonic exuberance found in a more fecund ecozone. One is instead confronted with the discreet, brittle whisperings characteristic of places in which water is scarce. It's as if each thing that lives here is conserving its energy, waiting for the perfect opportunity to reveal itself.

The Land is owned by artists Tom and Edite Cates, who share it as a place to make site-specific art that interacts respectfully with the environment. In the summer of 1999 I was invited by my friend, artist/curator Christine Wallers, to participate in The Land's second group show, to be held that fall. Having never been there, and with no idea what I might do for the occasion on such short notice, I agreed to at least go down and have a look around. Wandering the trails during that first visit, I was impressed by the sense of stillness, and by the delicacy and beauty of the few sounds I did hear. Feeling apprehensive about creating anything intrusive, I decided

that my project should be about listening to what was there, directing attention to the sounds and silence of the place itself, rather than making any noise of my own. I soon realized that I was proposing to develop an intimate relationship with this place, and that this would require time.

Twenty-four hours of stereo field recordings were made over the course of one year, extending the length of a single day throughout a twelve-month cycle. Each continuous hour-long recording was made at a different location on The Land, during a different hour of the day or night. Several more hours of additional recordings were made using contact microphones attached to individual objects encountered on-site.

While listening back to the stereo recordings, I wrote brief texts describing what was heard during each hour. These may resemble "poems," but I prefer to think of them as transcriptions of "songs" that I overheard there. As in the recordings, I have tried to stay out of the way, to let the writing be simple and transparent enough to illuminate the true poetry that I observed.

Ultimately, these texts were etched into twenty-four stone benches, to be installed permanently on each of the sites where the corresponding recordings were made. An in-progress version with five prototype wooden benches was shown at The Land in October, 1999. Indoor installations of material from this project have since been presented at the Museum of Fine Arts in Santa Fe in 2001-02, and at 516 Magnifico Art Space in Albuquerque in 2002.

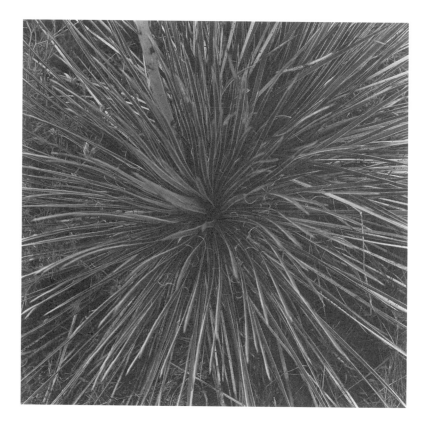

What interests me in excursions of this sort is the exoticism of the familiar. I am not drawn by expeditions into remote, untrammeled territories where no man, woman or child has set foot in a thousand years. What lures me in is that undiscovered country of the known world, the extant local landscapes where human events have flourished and faded.

JOHN HANSON MITCHELL, *Walking Towards Walden*

HISTORY

During my first visit to The Land, I sat in the shade and noticed a faint chorus of chirps and twitters in the distance. A flock of bushtits were making their way through the trees, feasting on juniper berries. I could sense their sound gradually approaching, aware that it would soon surround me, then pass by and fade away. As I listened and watched, the birds edged ever closer. Soon they were flitting visibly in the trees immediately ahead of me, then winging past me and off into the distance, moving beyond my range of hearing. I sat in the silence and golden light of the late afternoon, feeling that I had just witnessed a major event. A chapter in the secret history of the place. I became in that moment a historian of the minuscule occurence.

History is what has happened. As humans we favor events that involve us, deem them significant, commit them to public memory in stories and monuments. And in natural history we tend to record only the major cataclysms of weather, geology, extinction. But I want to propose a more inclusive idea of history, a greater scale of significance. I wish to suggest a history that acknowledges that every single event, no matter how small or seemingly inconsequential, whether observed or unnoticed by us, changes the world, brings about some subtle shift in the environment, and in each of us. Such events constitute the unknown history of the world.

This project is a record of some of those events, etched into plastic and paper and stone, an admittedly crazy but sincere attempt to insert them into our collective memory. I do not think of it as a catalog of the various kinds of sounds one might hear in this place, a list of resident species; rather, it is a document of specific sonic occurrences that I witnessed and wish to memorialize.

While recorded sounds and written words are a convenient way of recalling past experience, the benches are overtly monumental, serving as historical markers to further commemorate these fleeting incidents, telling a small part of the story of this place and my own evolving relationship with it. But they are participatory monuments, an invitation to sit and offer one's attention to the present. It is my hope that they can act as bridges across time and consciousness, that someone sitting on them might have an experience similar to mine. More importantly, though, the benches are intended as devices for directly engaging with what is happening in the moment. This implies a continuing process: the unfolding history of this place will be inscribed in the mind of each individual who pauses and deliberately attends to whatever may occur here—a multitude of diminutive events, noted and potentially remembered.

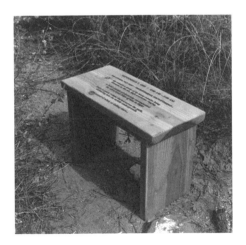

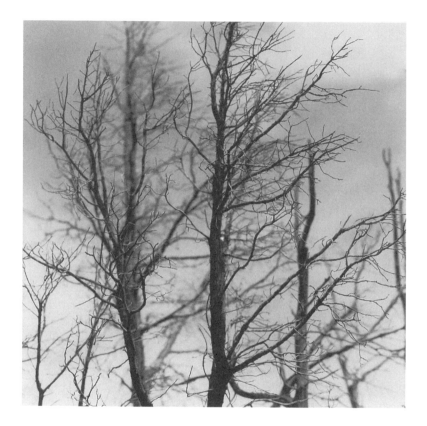

To engage in the erotics of place means to engage in time.

TERRY TEMPEST WILLIAMS, *Listening to the Land*

TIME

Time is an inextricable element of History and Place, the slippery medium in which all things are adrift. It is constant, flowing according to the logic of an inscrutable geometry. Lines and circles. Externally, we witness age and change, birth and death, and mark the wall to count the days; yet in our minds we cycle restlessly between memory and possibility, only occasionally coming to rest in the present to have a look around. Time has its own agenda, acts upon all things differently. The boulder that we imagine as eternal, Time knows to be soil in progress.

I chose to "do time" at The Land — sitting, listening, watching, learning—not as a sentence but as a committment, knowing that trust, revelation, connection come slowly and at their own pace. Here I've felt time in my body as aching muscle, sore butt, chilled flesh, and sweaty brow; I've sensed its subtle shifts in tempo, felt the hours rush and drag, counted the minutes, or lost track of them entirely, suspended in a perpetual present. At certain moments time seemed to expand, revealing its granular texture, as if each particle could be held and examined as a unique object.

The digital numbers on the tape recorder mark one kind of time. The sounds recorded are clocks as well, a matrix of overlapping cycles and singular events. The act of recording/listening is about swimming in "real time": the pleasure of being completely, ecstatically—or, at times, rather uncomfortably—immersed in the moment. Listening back to those recordings offers another kind of pleasure: memory, nostalgia, reimmersion, and revelation, a chance to hear what was missed previously. To listen to a tape bends the rules of time, feels like stepping in the same river more than once. Yet each newly perceived nuance subverts the comfort of repetition, renders it all new again. Even the finished sound work, fixed indelibly in plastic, plays whimsically with time's flow: a day expands to span a year, an hour contracts to a few minutes, the seasons are randomly shuffled while maintaining the familiar clockwise sequence of a day's chronological flow. Time the shape-shifter—elastic and fluid, orderly but also chaotic.

And time itself became the model for organizing the overwhelming amount of recorded material accumulated during this process, the diurnal cycle and the constraints of the proposed medium offering a useful ready-made form: 72 minutes of CD time, divided by the 24 hours to be represented, works out to a tidy three minutes for each hour, with some extra time added for crossfades between sections. To me, these long transitions mirror the incremental progression of time, each moment bleeding seamlessly into the next, blurring the tenses to suggest a continuous present.

Even with that basic structural problem solved, I often found myself battling time during the editing process, struggling with the limitations I'd accepted in the bargain. It was a challenge to distill each hour down to five minutes, and the richer and more varied the content, the more difficult the job became. The dawn chorus at 5 a.m. was a perfectly structured composition: a few crickets, then a distant bird making an occasional sound and gradually becoming more active, then other birds joining in, then many more, finally climaxing with the coyotes, and then a reversal of this process, with the birds slowly dropping out until the air was nearly silent again. It hurt to whittle such a lovely, complete piece down to five minutes. I had similar difficulty with the mockingbird aria in the 7 a.m. hour, a virtuoso performance which was in progress when I arrived on the scene and continued long after the tape ran out; an excerpt hardly does it justice. The thunder storm at 7 p.m. lasted for nearly ninety minutes from beginning to end, a magnificent display involving numerous shifts in mood and intensity. To have successfully condensed such a complex entity down to several minutes seems a dubious accomplishment. It feels vaguely criminal.

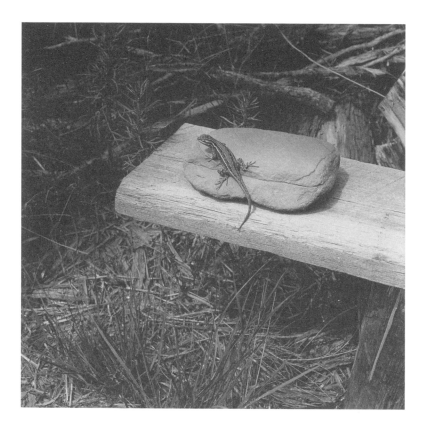

For the largest part of our species' existence, humans have negotiated relationships with every aspect of the sensuous surroundings, exchanging possibilities with every flapping form, with each textured surface and shivering entity that we happened to focus upon. All could speak, articulating in gesture and whistle and sigh a shifting web of meanings that we felt on our skin or inhaled through our nostrils or focused with our listening ears, and to which we replied — whether with sounds, or through movements, or minute shifts of mood.

DAVID ABRAM, *The Spell of the Sensuous*

ARTIFACTS

Throughout this project, I've considered the act of listening itself to be the real work; the recordings were a byproduct of that activity, a way to document my own listening experience and share it with others. While it's tempting to regard environmental sounds as potential material for composition, in this case I chose to forgo that musical impulse and instead present them as exactly what they are: the sonic manifestations of time and place.

Although the original field recordings have been subjected to extensive digital editing, no electronic signal processing was used other than basic equalization (boosting or filtering certain frequencies to make them more or less audible). Many sounds were relocated (always within the hour in question) or removed entirely. The latter is especially true in the case of trains and jets, a nearly constant element of this particular soundscape. I included a few of them for the sake of honesty and sonic variety, and because some of them are genuinely beautiful or evocative, but I did not want them to dominate the entire work. The result is that the site sounds far more pristine than it is.

I've also intentionally refrained from making this soundscape appear more lively than it really is for the sake of creating a more "exciting" recording. It would be tempting to take all of the highlights in a given hour and cram them into a few action-packed minutes, but that would deny the essence of the place. The truth of the site is that it is generally quiet, and on the surface there seems to be very little activity. Most of the sounds there are intrinsically not very loud, and are spaced far apart from each other in both time and distance. I have attempted to honor that spaciousness. This requires one to suspend expectations and accept what is offered, to listen on the terms set by this particular soundscape. Far from finding this boring, I appreciate being able to hear each sound as a distinct entity framed by relative emptiness. It causes me to listen more intently. Doing so, more subtle details emerge. I hear very little actual silence, and when I do, it seems miraculous.

The locations for the hour-long stereo recordings were usually chosen spontaneously. A quick walk would reveal where the most sound activity was happening, and I would set up there. I had a few particular spots in mind, and I waited for the right conditions to record those. Often there was nothing to recommend one locale over another, and so I would choose a site based on its visual appeal. Most of the recordings were made along the main trail that winds through only a small portion of the property, but some took place in more remote areas that no one but the owners will likely ever visit.

At times I made special trips to The Land to explore the sounds of particular objects using contact microphones, simple transducers that are the sonic equivalent of microscopes. The experience of listening in this way can be likened to putting on a diving mask and looking beneath the surface of the ocean. One discovers a beautiful and amazing world of sound hidden all around us, the internal resonance of trees, plants, and other objects, both natural and man-made. Often, the most unlikely or seemingly ugly things reveal wonderful interior sounds: having long disparaged the fence that runs the perimeter of the property, I held my ear to it on a windy day and heard the lush drone of grass beating against the taut wires, and the low frequency vibrations sent out through the earth by passing trains. What I had once considered an insult became a thing of beauty.

These "close-ups" represent a more active and investigative mode of listening, in contrast to the receptive/passive approach of the ambient recordings. I generally tried to resist the urge to manipulate the things I was recording, preferring instead to record them being activated by the wind. The exceptions are the plucked and bowed twigs of a juniper branch, and cactus spines stroked with stalks of grass. While interacting with these objects, I made an effort to avoid any overtly musical gestures. My goal was to simply play them with an empty mind, free of intention, open to exploration and delight.

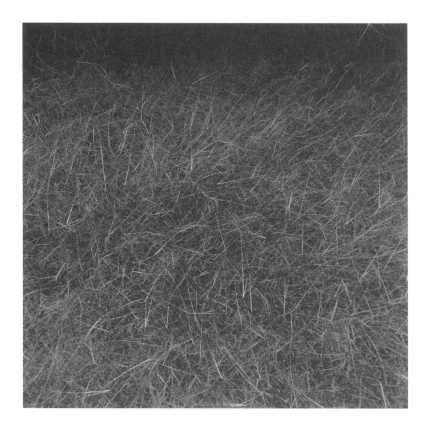

But whatever we learn

is only the skin

beneath which blurred organs

pulse and function.

RICHARD GROSSMAN, *The Animals*

(NOT) KNOWING

Out here in The Great American West, we harbor an abiding sentimental attachment to the idea of Space, yet we have seemingly little regard for the concept of Place. We exalt our mountains, deserts, rangelands, and coastlines, all the while building an endlessly sprawling network of suburbs and freeways that are gradually devouring all that is authentic and wild. Because ours is such a mobile culture, many of us have never stayed long enough in one place to become a part of it, or to let it become a part of us; indeed, many of us consider this a nonissue. We almost pride ourselves on being able to pick up and leave without a single regret or backward glance. We want a place to satisfy our immediate needs, but feel no obligation to care about it beyond its ability to do so. We are unskilled in the ways of truly engaging with Place—to know it, to love it, to make it our home. Perhaps this is a form of self-protection: I suspect that if we allowed ourselves such an intensely emotional connection to Place, the loss, pain, and guilt many of us would feel upon acknowledging the sad truth of what we have done and are still doing, and the depth of our alienation, would be unbearable.

Having been raised in such a culture, I long for a sense of deep relationship with the place in which I live, and with those places that I love. I want to know where I am, to explore all of the secret corners and find out what and who lives there. This was my intention when I came to work at The Land. It was an opportunity to practice the conscious development of intimacy with Place.

Nearly three years later, I have yet to fully realize those intentions. I'm embarrassed to admit that I still don't know the common (human) names for many of the things that live there. But I also believe there is more to knowing than merely categorizing and naming. There is attention, there is memory and recognition. When, during my visits, I encounter a particular bird or plant, I may not always be able to identify it by name, but somewhere in my brain I've filed away notes about its significant

features, and I usually know if we have met before. This, too, is a form of knowing. In a funny way, I suspect that an unforseen result of our diligence in assigning names to things is that it allows us to become lazy about being present with them. We say "Crow" and continue on our way, thinking we know what Crow means but not truly attending to each particular instance of crowness. Without the convenience of a name to pin on something, one learns to identify it according to its essential qualities.

As I put in more time at The Land, I learned where certain sounds might happen, and at what times of the day or year they could be expected, how they change with the seasons. I came to know how the grasses sound when green and when dry, how the wind interacts with different trees, that power lines only crackle when they are wet with rain or dew. I remember where to find that one plump cactus with the amazing crimson blossoms, and which juniper tree has the crossed branches that rub against each other to create a squeaky two-note melody. I discovered that red harvester ants exchange the most astonishing shrieking noises with one another through the act of stridulation. And over time I did learn to distinguish between the hysterical *waaaah!* of a piñon jay and the harsh scream of a scrub jay, that juncos *blip* as well as *peep*, that spotted towhees say *Yeeeaaah!*, that diving nighthawks were the source of that spooky honking sound, and that train whistles apparently inspire coyotes to howl.

After a while, I began to feel as if the place was coming to recognize me, too. It was all so clearly alive and aware, and in its own ways communicating, responsive to whatever was happening. The birds seemed to grow more curious about me, becoming increasingly bold, flapping around in the trees closest to me, or hopping on the ground a few feet away, taunting me. Some of them even attempted to perch on my microphone stand. Hummingbirds flew up to my chest, mistaking my

red sweatshirt for a source of nectar. I suppose that some of this behavior could be explained as defense of territory, or an attempt to distract a potential predator away from a nest. But it never struck me as hostile or confrontational; rather, it always seemed playful and engaging, an attempt to interact. And it seems significant to me that such behavior did not occur right away, but only after I had been there many times.

Once, I noticed an unusually large pine cone in the arroyo, where it intersects with the dirt road that leads into the place. I looked further up the wash and saw another, and followed a trail of them that led me deeper into The Land, away from the established trails and my usual haunts. I finally arrived at a large Ponderosa pine, the only one I'd encountered on the property. It felt like some intimate secret had been revealed to me, one I might never have learned had a flash flood not randomly washed those pine cones down that arroyo, far from their source, to pique my curiosity. It may be irrational, but I like to believe that they were put there in order to draw me in, to get me to venture beyond what had become familiar to me. It's true that at some point I might have wandered up that way on my own, but it's also true that after that I tended to forsake the trails much more often.

By now, going to The Land is like visiting an old friend. We have a shared history; time spent together. I notice what is new, what has changed, what remains familiar. But there is still much for us to learn about each other, and much more that can never be known.

24 SONGS

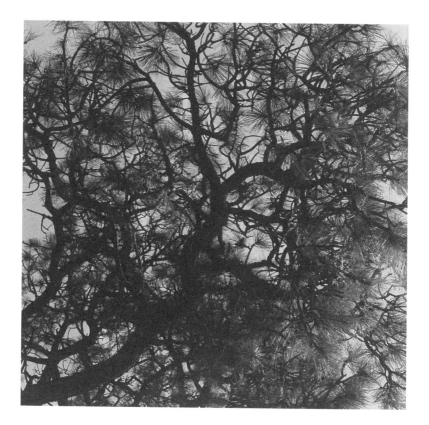

Thus have I heard…

midnight (june 18, 2000)

low hum and crackle of power lines
lightning illuminates the void
between horizon and clouds

a nighthawk calling and diving
calling and diving
wings slicing the darkness

a freight train's horn
answered by yipping coyotes in the east
and by their kin to the west

soon joined by a chorus of local dogs
then mourning dove
then mockingbird's midnight song

1:00 am (october 25, 1999)

a long, miraculous stretch of absolute silence
beneath icy full moon glow

no cricket, coyote
bat or train
or even wind

nothing
but the body's living sounds

breathing
swallowing
digestion
nervous system

roused suddenly by
the phantom hiss of great, gliding wings
an owl, perhaps

2:00 am (july 19, 2000)

subliminal, alien drone
like distant frog pond chorus
mating spadefoot toads?

a startled dove bursts from its roost
rudely awakened

many crickets chirp in the damp grass
wary hound, anxious rooster
the trains never sleep

the mysterious drone remains

3:00 am (august 1, 2000)

crickets sparse
humming softly in the grass
setting scattered stars to song

a bird emits a single *peep*
and a dog barks
starting a chain reaction across the mesa

in deepest night
all the world seems to sleep
yet a few crisp snaps of something unseen

falling leaf, or small creature
scuttling in the grass
a nighthawk plunges into deep space

4:00 am (september 7, 1999)

one cricket, very near
starts/stops
starts/stops

the ringing of countless others
their high overtones hung
like mist in the air

buzz of electricity, and
ultrasonic blips of bats in flight

twice a quick rodent darts across the path
skittering into brittle undergrowth

no sound of wind
or falling stars

5:00 am (august 1, 2000)

the world awakens, one bird at a time

first a nighthawk
calling and swooping overhead

and another across the meadow
then a towhee, quite close

a dove, two jays
another towhee and more

then multiples of these
echoing over fields and hills

as crickets fall
slowly silent in the warming sun

coyotes howl, then the dogs
neighbors stir, and a train rumbles away

6:00 am (august 9, 1999)

an exuberant chorus
of many layered voices
joyful cacophony

westbound freight takes its time
fading into silence, and the birds
go quiet in its wake

a few crickets linger, then
nothing stirs but
shadows in the grass

soon another train
not as long, headed east

7:00 am (may 28, 2000)

a rowdy gang of piñon jays clatters past
a gaggle of giggles, a whir of wings

old man crow is serious, dignified
no time for games or silliness

a pair of kingbirds do their mating dance
flapping and screeching with desire

mockingbird spins endless variations;
not a hermit thrush, but meadowlark

8:00 am (february 29, 2000)

steady, insistent cry of townsend's solitaire
heep . . . heep . . . heep . . . heep . . . heep . . .

an occasional crow, jay
or other small bird

one of them lands nearby
wings and air

wind softly rattles pine needles and grass
bringing the long, low whistles of trains

neighbors go about their living
children's laughter, slamming doors

9:00 am (february 2, 2000)

gusting wind articulated
by ponderosa pine's graceful needles
as low rumble of distant ocean waves

curious scrub jays flap
and scream in surrounding piñon
trying to provoke a response

cranky ravens wheel high above
clucking and cawing their disapproval
patches of midnight adrift in azure sky

the gentle arc of a jet
a lonesome train whistle
a persistent towhee

in the end, only wind

10:00 am (december 27, 1999)

the birds come to see the odd, human thing
neither rock, nor tree, nor cholla
standing dead still in midwinter morning sun

they fly in close, curious and bold
darting about, fluttering and clucking
trying to make sense of it

getting no reaction
they lose interest and
resume their morning routine

flickers peck at gray juniper limbs
their hawkish cries tossed on the breeze
a flock of juncos twitter in the brush

11:00 am (november 26, 1999)

a stray sheet of newspaper
rustles in the wind

bearded grass drums upon its surface
giving it rhythmic purpose here

reading the weathered words
not as litter, but a lovely music

the grass itself barely audible
all the more beautiful for that

a piñon jay pecks busily at dry wood
then calls out suddenly

summoning hidden comrades
to convene and observe

midday *(january 29, 2000)*

a hush falls upon the land at midday
but for the wind murmuring low

a very few sounds come
it seems, from a great distance

a dog, a crow, a jay
the voices of children across the hill

a single jet makes little disturbance
even the trains are at rest

1:00 pm (november 26, 1999)

two dry juniper branches
scrape gently against each other

their delicate abrasions
random, pleasingly melodic

a lone raven calls to no one in particular

the collective whisp and rattle of grass becomes,
at ground level, many distinct voices

a gift of juncos, meeting in the old tree
their *peeps* changing abruptly to *blips*

2:00 pm (october 22, 1999)

sandhill cranes gabbling high above
invisible in autumn's blue depths

a pair of crows shout at each other
across the open field

snapping red-winged grasshoppers describe
a series of brief arcs, from there to there

their smaller kin lie hidden
discreetly hissing in the black grama

the lanky stalks tremble and sigh
as a dozen piñon jays stir the air

3:00 pm (december 19, 1999)

a strong wind conjures aeolian music
from power lines and fence wire

howling through juniper, and
thrashing the dry winter grass

jays chatter across the meadow
as the gale grows stronger

and a droning airplane intones
harmonic gliss across the sky

4:00 pm (september 6, 1999)

late afternoon, stillness
several birds
a sudden riffle of wind

five intermittent grasshoppers
one of them, gnawing at a leaf
surprisingly audible

a pair of indecisive crickets
a few itinerant bees
and 255 flies

5:00 pm (january 16, 2000)

a hush, almost sacred
as evening settles into twilight

clouds shifting in shape and color
pale moon frosted in lavender mist

distant power lines glow, ropes
of golden light strung elegantly to the horizon

richly mingled overtones of train and jet

the delicate rhythm
of a lacy green moth fluttering its wings

6:00 pm (august 8, 1999)

songs of solitary birds in flight
dove, hummingbird, nighthawk, jay

deep rumble of clouds colliding in the southern sky

wind whisps through juniper and tall grass
gathering velocity as the storm approaches

thunder cracks sharply overhead

four or five crickets rasp steadily
grasshoppers, flies, birds behind them

finally, light rain spatters on earth, grass, and stone

7:00 pm (july 18, 2000)

the sky fills with hovering nighthawks,
blown in upon the monsoon's crest

the trees mumble and moan, as thunder
builds slowly in the gathering clouds

electricity reaches across the darkened sky
and rain shifts from drizzle to downpour

its thrumming patter upon roof and ground
and musical ping on each metal surface

rises to crescendo, then subsides
as the storm rolls onward

8:00 pm (may 27, 2000)

doves roosting in the light's last fading
their mournful cries and *wheeping* wings

a hummingbird hunting for nectar
deep throb and nervous twitter

the nighthawk's persistent, piercing call
stops suddenly as it hovers, then falls

astonishing hum of air through feathers
as it pulls from its dive, hurtling skyward

9:00 pm (july 31, 1999)

cricket

cricket

cricket

cricket

cricket

cricket

cricket

cricket

cricket

cricket

cricket

cricket

cricket

cricket

cricket

TRAIN–TRAIN–TRAIN–TRAIN–TRAIN–TRAIN–TRAIN–TRAIN–TRAIN

cricket

cricket

cricket

cricket

cricket

cricket

cricket

cricket

cricket

cricket

cricket

10:00 pm (june 17, 2000)

not quite silence
but stillness, in spite of trains

a few crickets widely dispersed
two neighbors singing in crossed rhythms

piñon and juniper seem to whisper
as if windblown

yet no branch trembles
nor a single tuft of grass

11:00 pm (april 13, 2000)

a deep, molecular emptiness
hangs in the air
time holding its breath

an owl calls from afar
barely rising above
the thin, black line of silence

a dog barks, once

a train whines at the cusp of audibility
drifts seamlessly into jet noise and
dissolves in the midnight sky

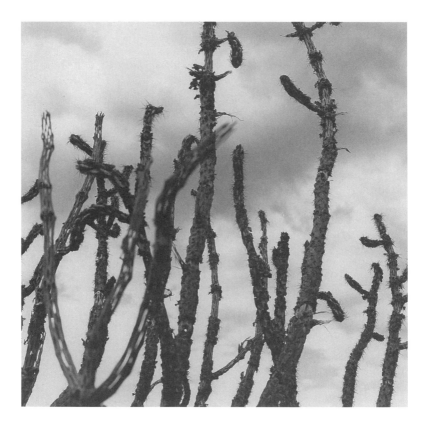

THE RECORDINGS

Recorded, edited and mixed by Steve Peters
Mastered by Manny Rettinger at Ubik Sound, Albuquerque
CD produced in cooperation with Pianissimo Recordings

RECORDING EQUIPMENT:

Tascam DA-P1 portable DAT
AKG C-522 stereo microphone
piezo contact transducers
Sony parabolic dish with
Sennheiser K6 omni microphone

The edited ambient field recordings are arranged on the CD in clock sequence, though calendar-wise there may be huge temporal leaps between tracks. The segments also overlap to varying degrees, resulting in boundaries which are not so obvious. At each index point on the CD, the sound representing that hour is at its full volume and remains constant for three full minutes, while the previous hour can still be heard fading away, and/or the next hour is gradually fading in (outgoing or incoming segments are listed in parentheses).

The contact microphone recordings (listed in italics) were made separately from the ambient recordings, and are not presented in any logical order; instead, they are laced throughout the other recordings according to the whims of my own ear. Rather than emphasizing these sounds by placing them in the foreground of the final mix, I have chosen to embed them discreetly within the larger soundscape. As in the real world, a certain amount of effort is required to hear them.

The overall volume is generally quiet, and much of the sound is extremely subtle. I suggest adjusting your volume level so that the thunderstorm on Track 19 is fairly loud. This will result in appropriate listening levels for the other tracks. Use of headphones is encouraged.

1. midnight to 1 a.m.
 train rumble
 nighthawk calls
 mockingbird
 crickets
 nighthawk dive
 train whistle
 coyotes

2. 1 a.m. to 2 a.m.
 (train etc. out)
 dog howls
 gliding owl wings
 (crickets & drone in)

3. 2 a.m. to 3 a.m.
 crickets
 mystery drone (toads?)
 juniper plucked
 juniper bowed
 (soft crickets in)

4. 3 a.m. to 4 a.m.
 (crickets, drone out)
 soft crickets
 dog barks
 juniper ends
 (loud crickets in)

5. 4 a.m. to 5 a.m.
 (soft crickets out)
 loud crickets
 flying insect
 wire fence in wind
 (towhee & nighthawk in)

6. 5 a.m. to 6 a.m.
 (loud crickets out)
 spotted towhee
 wire fence ends
 nighthawks
 crickets
 ants walk on mic
 (dawn chorus in)

7. 6 a.m. to 7 a.m.	(towhee & nighthawks out)
	dawn chorus:
	nighthawks
	scrub jays
	mourning dove
	kingbird
	towhees
	various songbirds
	flapping wings
	coyotes & dogs
	ants swarm on mic
	(kingbirds, mockingbird in)
8. 7 a.m. to 8 a.m.	mating kingbirds
	mockingbird
	towhee, etc.
	ants chew mic
	train engine & whistle
	ant stridulation
9. 8 a.m. to 9 a.m.	(dawn chorus out)
	ant stridulation
	train engine & whistle
	airplane
	ants end
	townsend's solitaire
	(wind, crows, juncos, jays in)
10. 9 a.m. to 10 a.m.	(townsend's solitaire out)
	wind in ponderosa pine
	jays screech, flap, cluck and peck
	pine limbs scrape in wind
	spotted towhee
	very quiet jet
	crows
11. 10 a.m. to 11 a.m.	(jays, crows, towhee out)
	wind in pines
	fluttering wings
	scrub jays

 flock of juncos
 train engine
 pecking
 pine branches end
 scrub jay
 mockingbird
 (juncos & towhee in)
12. 11 a.m. to midday (jays etc. out)
 train gets louder
 juncos & towhee
 cactus spines stroked & plucked
 piñon jay pecks & vocalizes
 fluttering wings
 train whistle
 piñon jay calls
13. midday to 1 p.m. (train out)
 piñon jay calls, others arrive
 cactus ends
 flock of juncos
 flock of starlings
 (wind in dry grass in)
 crows
 dry arroyo bush in wind
14. 1 p.m. to 2 p.m. (juncos etc. out)
 wind in dry grass
 flock of juncos
 arroyo bush ends
 quiet jet
 distant train whistle
 blue fescue in wind
15. 2 p.m. to 3 p.m. (wind in grass out)
 grasshoppers& flies
 blue fescue ends
 bushtits
 hollow cholla branch in wind
 (grass & scrub jays in)

16. 3 p.m. to 4 p.m.

(grasshoppers out)
wind in black grama grass
scrub jays
juncos
(unknown bird in)
jet & train engines
flies
train whistle

17. 4 p.m. to 5 p.m.

(wind in grass out)
unknown bird
fly on mic
four wing salt bush in wind
cholla ends
various birds
(train engine in)
arroyo bush in wind
grasshoppers

18. 5 p.m. to 6 p.m.

(grasshoppers out)
train engine mixes with jet
flies
arroyo bush out
new grasshoppers
mystery bird
juniper branches scrape in wind
(crickets, nighthawks in)

19. 6 p.m. to 7 p.m.

(train, jet out)
crickets
nighthawks
unknown bird
fly on mic
thunder
wind in piñon & juniper
juncos
crickets
(rain in)

20. 7 p.m. to 8 p.m.

(crickets out)
falling rain
nighthawk
thunder
juniper branches end
storm intensifies
(mourning doves)

21. 8 p.m. to 9 p.m.

(rain ends)
fluttering wings
hummingbird
mourning doves
kingbirds
last thunder
scrub jays
mockingbird
crickets
noisy jay perches near mic
train whistle
spotted towhee
fly
grass blown on wire fence
(field crickets in)

22. 9 p.m. to 10 p.m.

field crickets
nighthawks
(evening birds out)
train whistle & engine
(cricket duet in)

23. 10 p.m. to 11 p.m.

(field crickets out)
cricket duet
wire fence ends
solo cricket
train gradually fades
(power lines in)

24. 11 p.m. to midnight

(cricket duet, train out)
crackling power lines
distant owl hoots

ACKNOWLEDGEMENTS

I am grateful to Tom and Edite Cates for sharing their beloved place with me, and to Christine Wallers for dragging me there in spite of my initial skepticism. Late in the game, I invited Margot Geist to share my obsession; she got the idea, and made it her own. I appreciate her help in transmitting the experience more completely through her images. My wife, Mary Roy, contributed the pleasure of her company in the field and at home, as well as her enthusiasm, support, and indulgence.

Jeff Bryan kindly offered to give this project a home at La Alameda Press, where I'm in excellent company. David Abel brought his invaluable editorial insight to the text, improving it significantly. Annea Lockwood, Kate Horsley, and Leslie Staub all read early drafts, offering useful comments and encouragement. Giancarlo Sadoti helped to identify many of the birds on my recordings, greatly enhancing the content of the *24 Songs*.

Michael Motley has designed many projects for me over the years, and it was a pleasure to work with him on this one. Steven M. Miller generously and patiently tutored me in the mysteries of digital audio editing; without his help I would have probably given up, or at the very least broken something. Thanks also to Kim Arthun and Kay Whitney for their help in constructing the listening benches.

There is a lineage of composers and audio artists whose work is firmly rooted in listening to the sounds of the world. They have made daily life (and music) a richer experience, and I owe them an immeasurable debt for all I have learned from their example. The same is true for their literary counterparts, whose words about the environment have inspired me, and for those visual artists whose work is engaged in a dialog with time, place and natural phenomena. Their collective influence is acknowledged and appreciated.

RESOURCES

THE LAND/AN ART SITE, INC.

(419 Granite NW, Albuquerque, NM 87102 USA; www.thelandanartsite.com) is a non-profit organization operating a fifteen-acre work site and exhibition space in Mountainair, New Mexico, dedicated to environmentally sensitive, site-specific land-based art.

EARTH EAR/ACOUSTIC ECOLOGY

(45 Cougar Canyon, Santa Fe, NM 87508 USA; www.earthear.com) offers an extensive catalog of recordings and books related to environmental sound, and acts as a central clearinghouse for existing organizations, information about sound-related initiatives and environmental issues, and access to academic research, public policy advocates, and articles and essays about sound and listening.

THE NATURE SOUNDS SOCIETY

(c/o The Oakland Museum of California , 1000 Oak Street , Oakland, CA 94607 USA; www.naturesounds.org) is a world-wide organization dedicated to the preservation, appreciation and creative use of natural sounds, composed of biologists, museum professionals, conservationists, sound designers, musicians, artists and radio broadcast specialists concerned with ambient natural sound. They promote education on the technological, scientific and aesthetic aspects of natural sound, publish a newsletter, and sponsor various events and activities.

WORLD FORUM FOR ACOUSTIC ECOLOGY

(c/o College of Education, University of Oregon, Eugene, OR 97403 USA; http://interact.uoregon.edu/medialit/wfae/home/) is an international association of affiliated organizations and individuals sharing a common concern with the state of the world soundscape as an ecologically balanced entity. Their membership represents an interdisciplinary spectrum of people engaged in the study of the social, cultural and ecological aspects of the sonic environment. The WFAE also oversees an online discussion group, and publishes a journal, *The Soundscape*.

ABOUT THE ARTISTS

STEVE PETERS was born in northern California and raised in the suburban zone between Los Angeles and San Diego. He settled in New Mexico in 1988, and lives near the Rio Grande in Albuquerque. He makes music and sound for dance, theater, film, radio, museums, galleries, public spaces, and concert settings. His other CD releases include *Emanations* (O.O. Discs) and *In Memory of the Four Winds* (pianíssimo).

MARGOT GEIST has long been enamored with light and the way it passes through a lens, and began studying photography with her father at the age of five. Her personal and commercial work has been exhibited and published nationally. She owns and operates Geistlight Photography, a commercial photography business in Albuquerque, New Mexico.

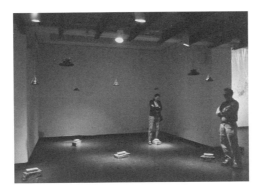

Installation view, Museum of Fine Arts, Santa Fe, 2001-02

COLOPHON

Set in *Adobe Garamond*
designed by Robert Slimbach (1988)
— a version of the French Renaissance face
by Claude Garamond/Robert Granjon distinguished
by an x-height pared toward refined gracefulness.

&

Gill Sans
designed by Eric Gill (1927-30)
— a san serif based on the lettering he did for a sign on
the Bristol Bookshop in London and remains to this day
a distinctly readable meditation on circle and line.